Inspiration
of
JOY

My Art Portfolio of Five Years of Homelessness

MONICA C. RAMIREZ

To order additional copies of this book, contact:
Xlibris
844-714-8691
www.Xlibris.com
Orders@Xlibris.com

ISBN: Softcover 979-8-3694-1585-6
 EBook 979-8-3694-1584-9

Library of Congress Control Number: 2024902120

Print information available on the last page

Rev. date: 01/31/2024

About the Author

Monica C Ramirez, 55 years old; born Santa Barbara, California, Native to her Country North America is sharing with you her journal of how her homelessness supported her exposure to being an accomplished Published Artist.

From May of 2017 until July 2023 she lived in shelters, on the streets and even in a van for a bit. She became familiar with the homeless community and utilized there services for support. She would like to thank the Santa Barbara non-profit Organization for their support.

Monica's first homeless experience was a wanderer. Then she found to spend time at the Mental Wellness Center, a place to do Art. She became substitute Art Facilitator. Involved with the center, Monica C. Ramirez, Produced and Directed a 3 hour debut Talent Show. Entitled, "Peace, Love, Hope and Joy." All performers were members of Mental Wellness Center. Many were and are the homeless community of Santa Barbara. This Show was for their 65th Anniversary. Many compliments of the laughter and joy they experienced.

Monica, also, became a member of the Father Virgil Cordano Center. Fr. Larry and Fr. John from the Father Virgil's Cordano Center (a day center for homeless person's) really took notice to her talent. They encouraged her practice and provide a place to do her art. She also became the Art Facilitator for the center until Covid 19.

Monica has published a comical art book titled, "I 'm Not Dead Yet!" featuring "I N. D. Y! ". "I. N D. Y.!" is a funny creation of Monica's struggles in her life. She continues with her character "I.N.D.Y.!" and is working on book 2.

Monica enjoys her art work her painting give joy and happiness. Monica's, Art Portfolio My 5 year Journal of Homelessness is published to share with all the people. "Inspiration of Joy". Monica intends to continue her art and publish other more art books.

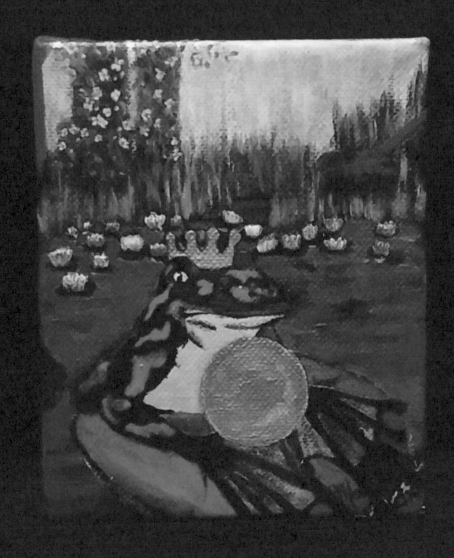

FROG PRINCE

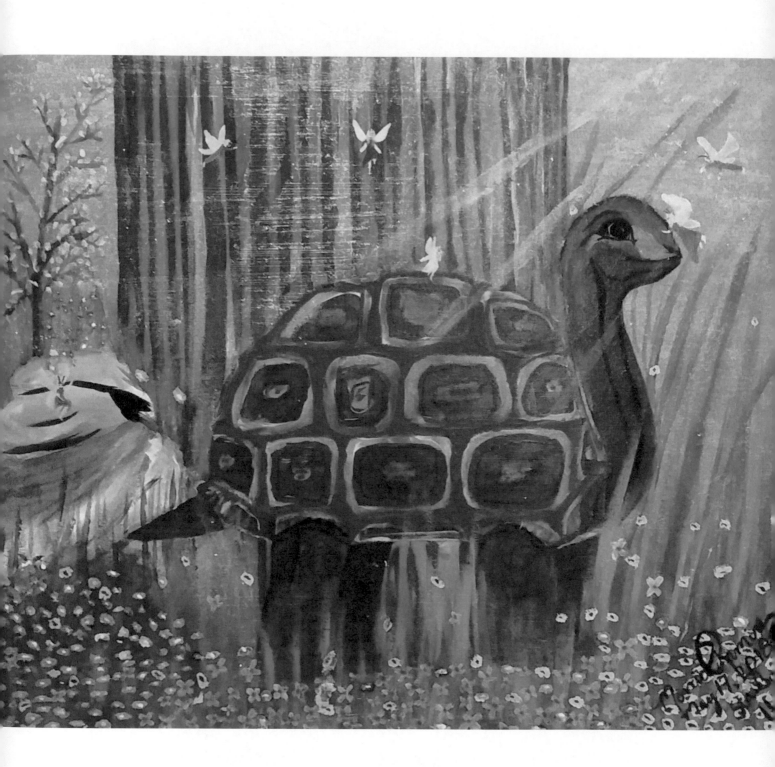

TORTOISE ENCHANTED BY FAIRIES

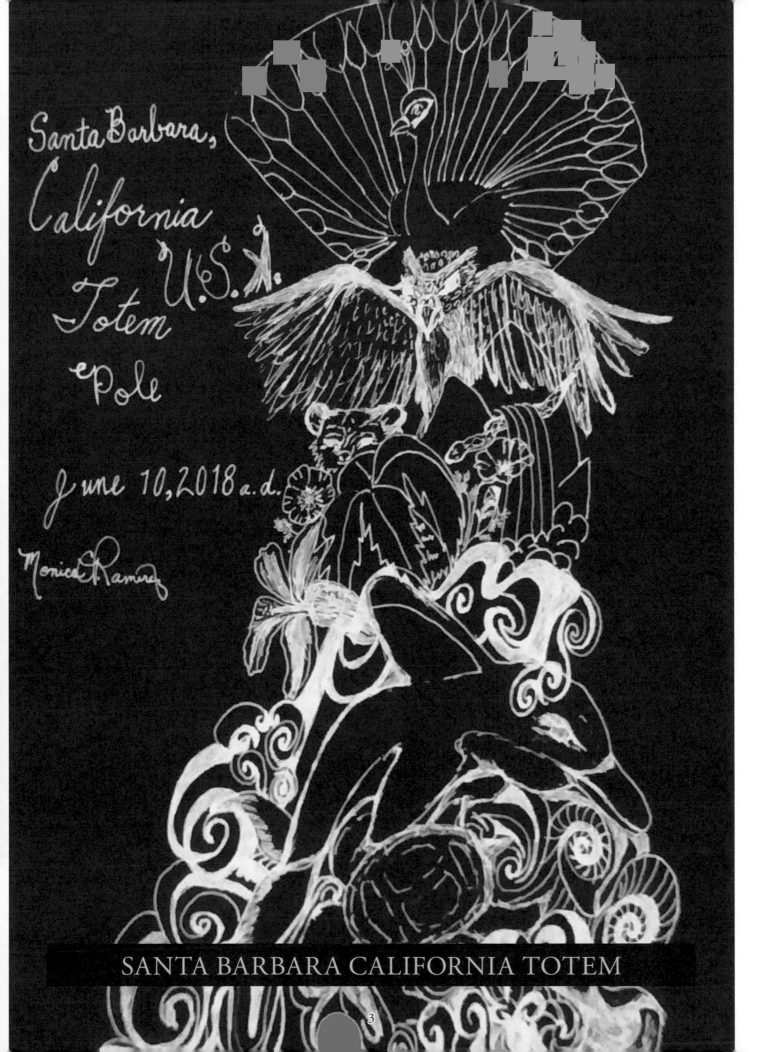

Santa Barbara,
California
U.S.A.
Totem
Pole

June 10, 2018 a.d.

Monica Ramirez

SANTA BARBARA CALIFORNIA TOTEM

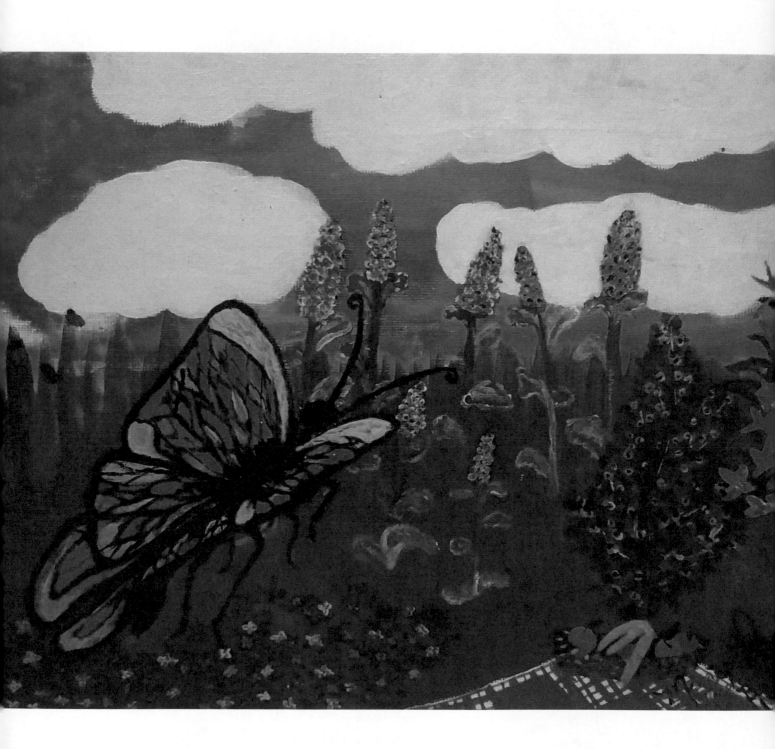

A VERY HUNGRY BUTTERFLY

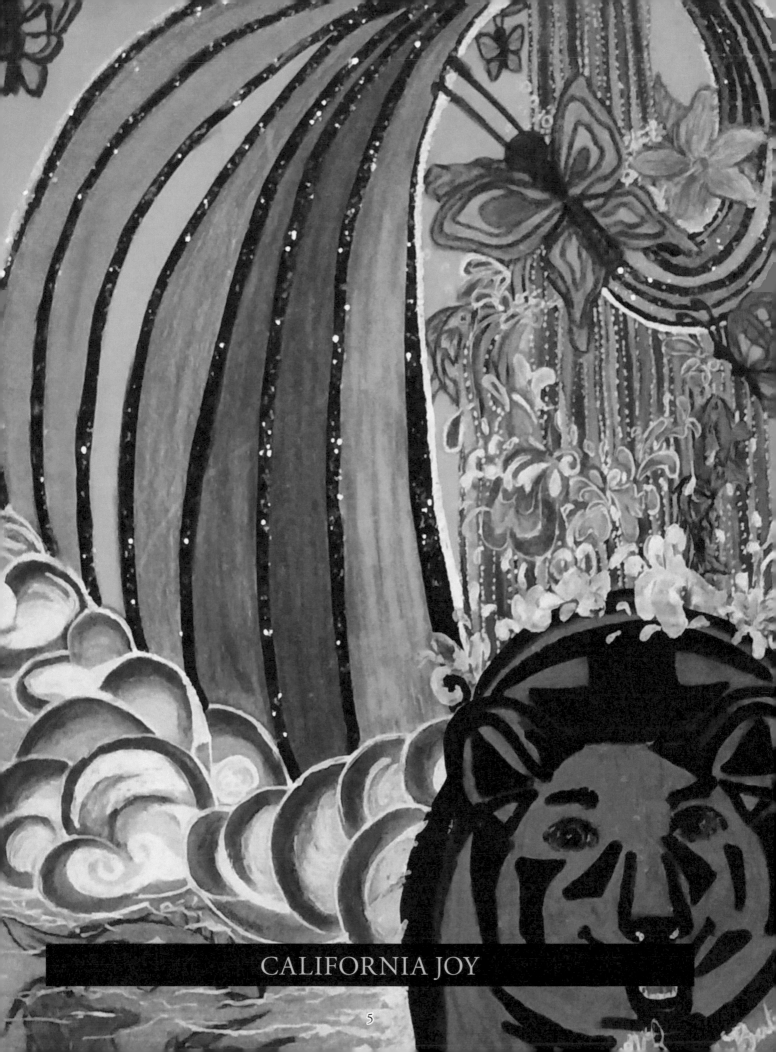

CALIFORNIA JOY

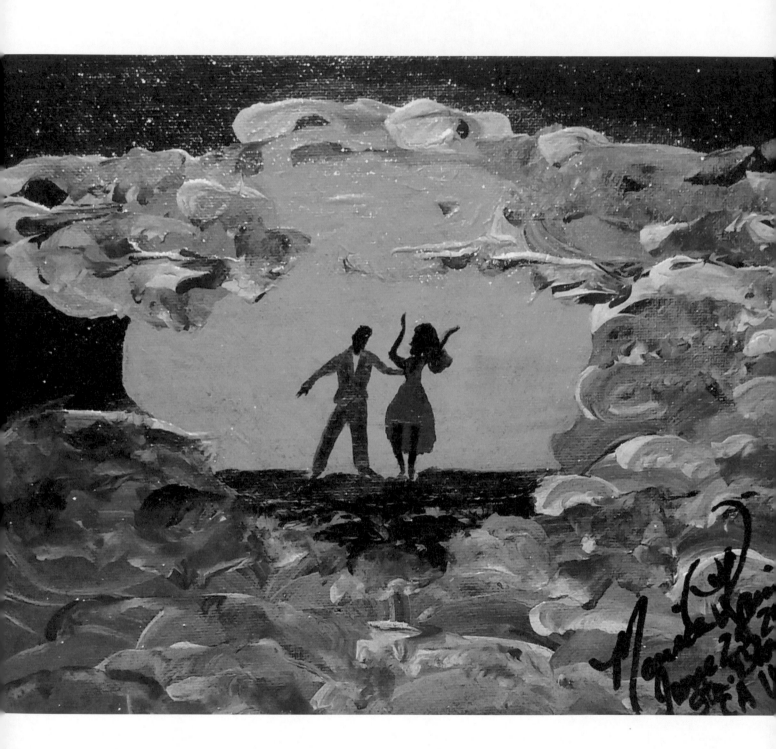

DANCING IN THE MOONLIGHT

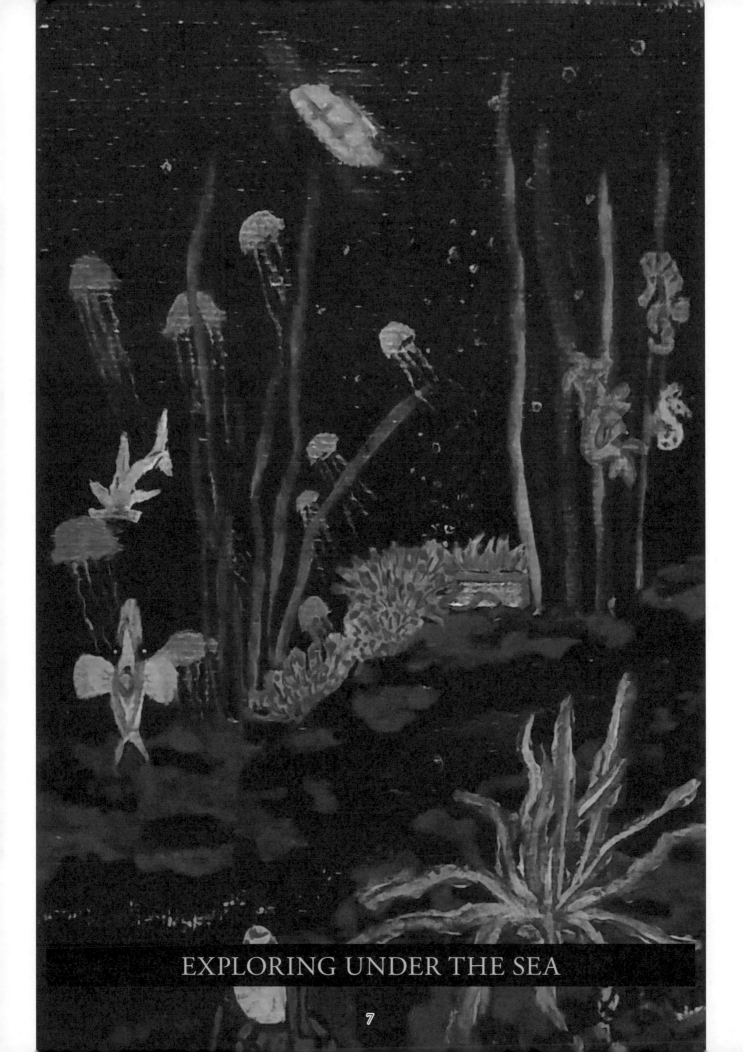

EXPLORING UNDER THE SEA

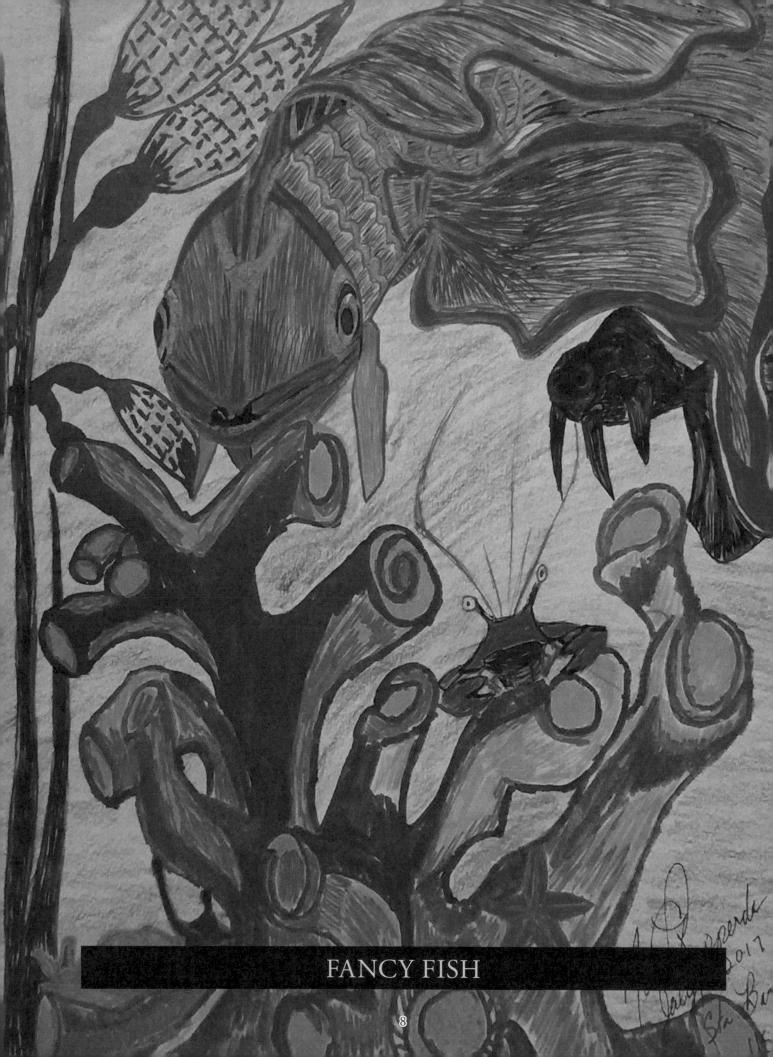

FANCY FISH

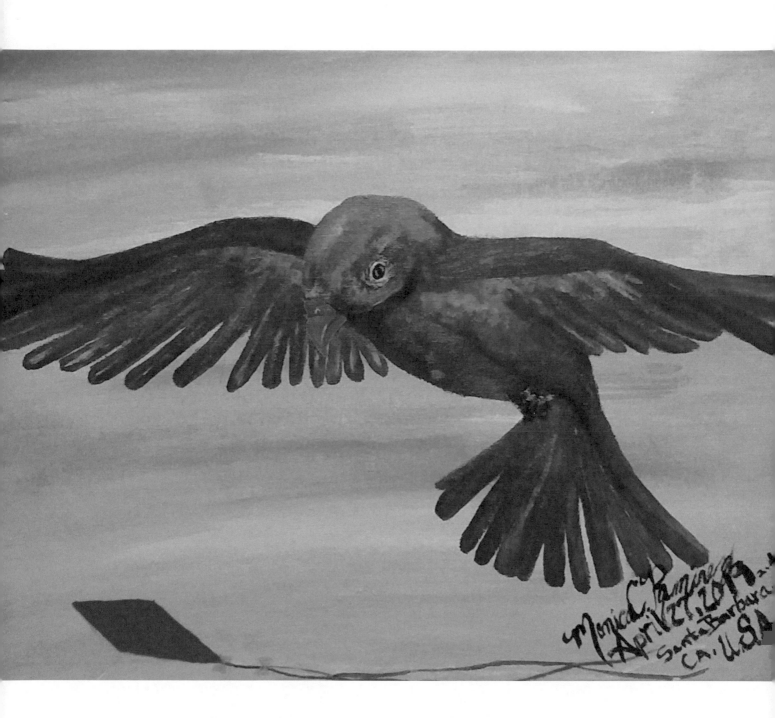

FLYING HIGH

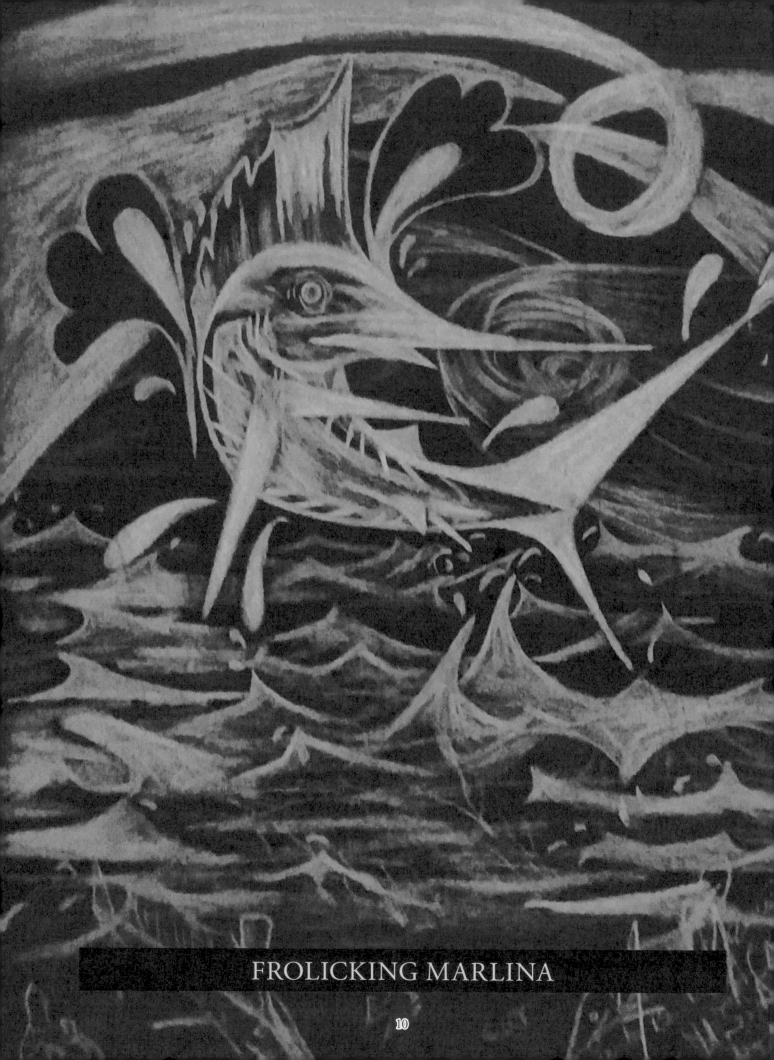

FROLICKING MARLINA

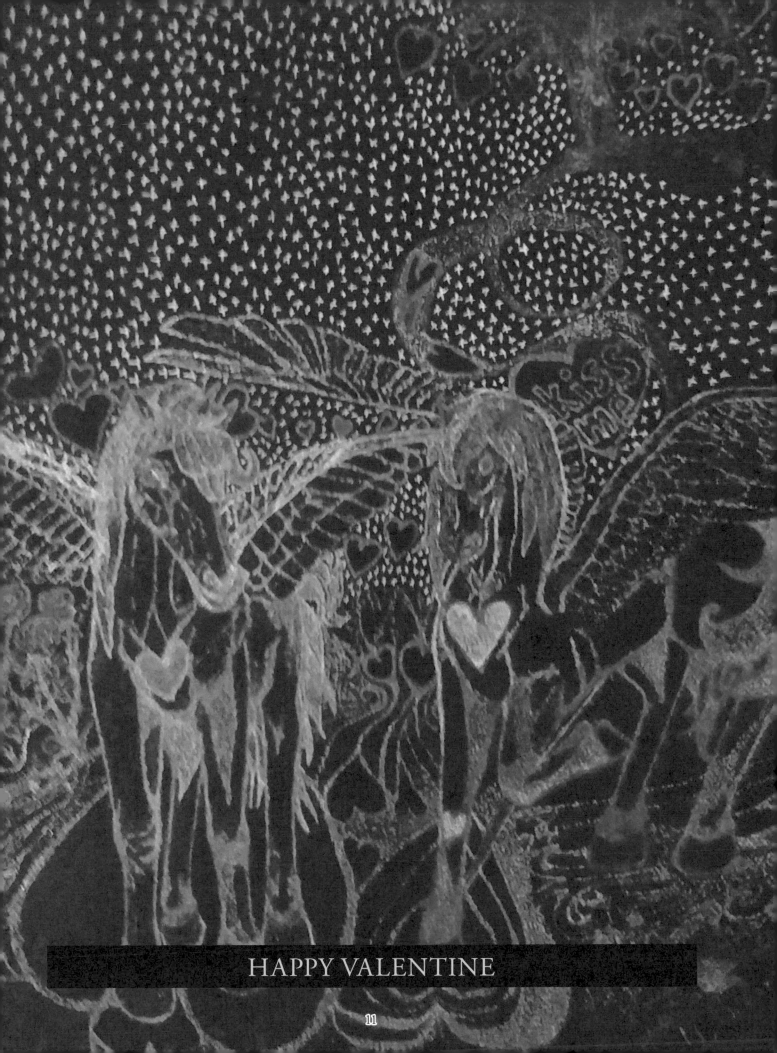

HAPPY VALENTINE

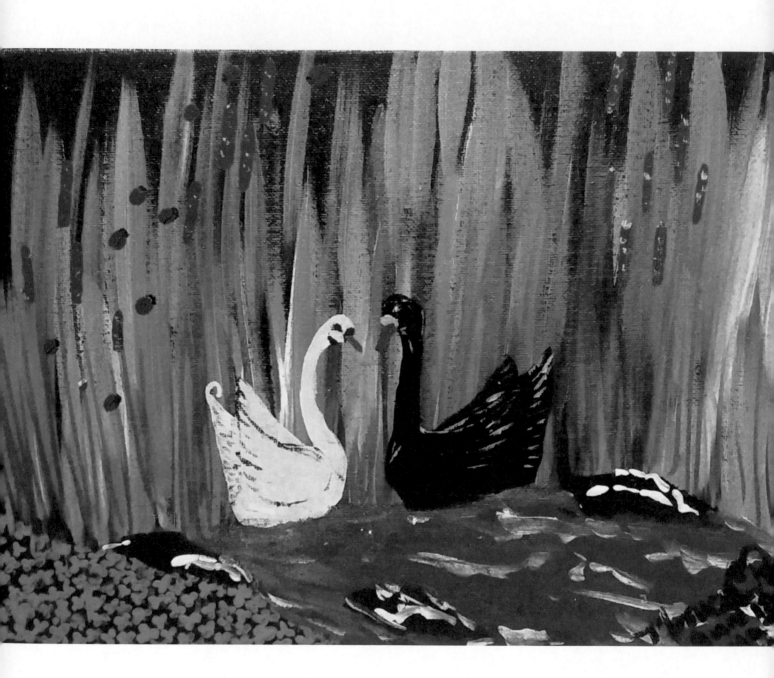

LADY BUG LUCK

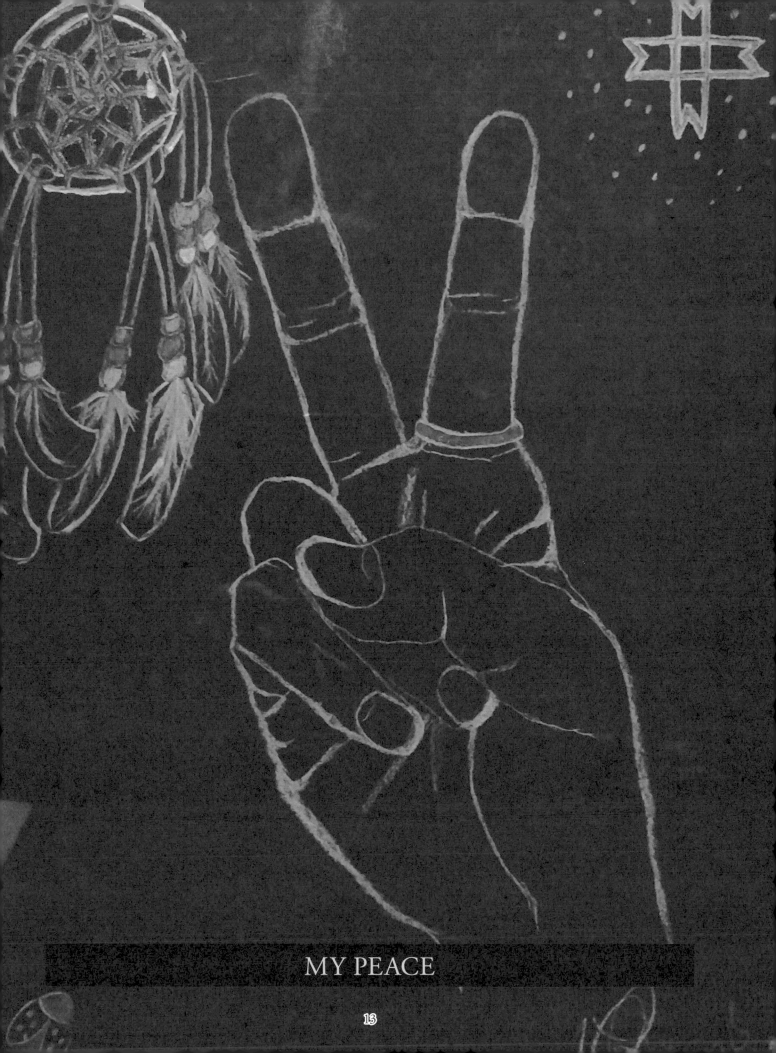

MY PEACE

NO MORE HYPNOTISM

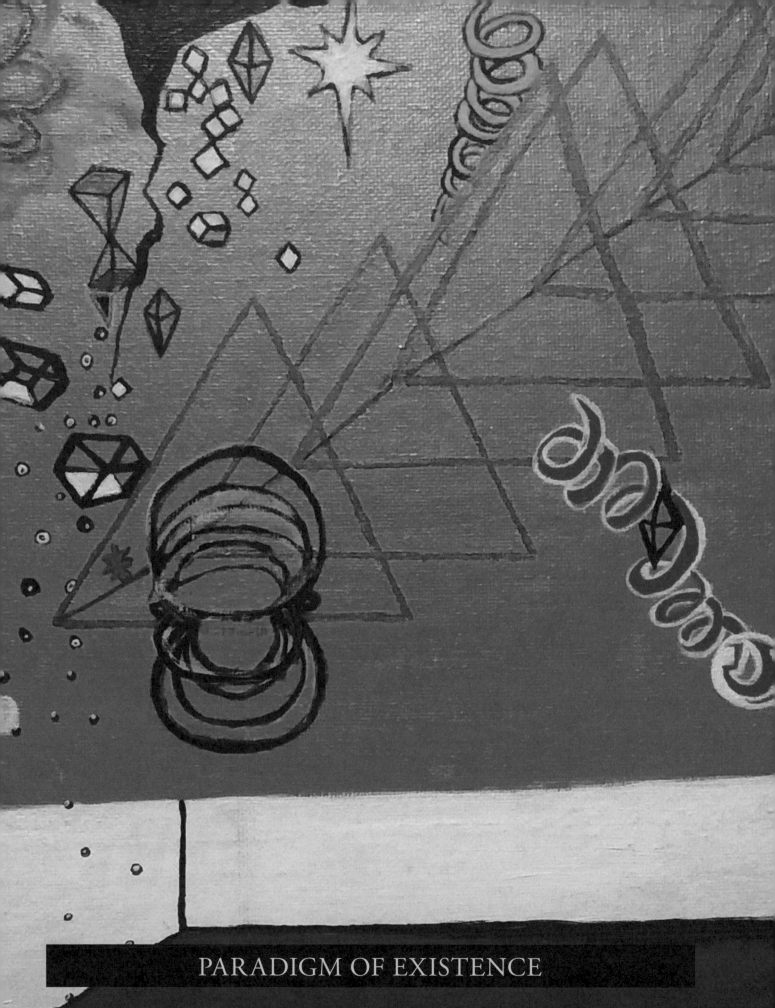

PARADIGM OF EXISTENCE

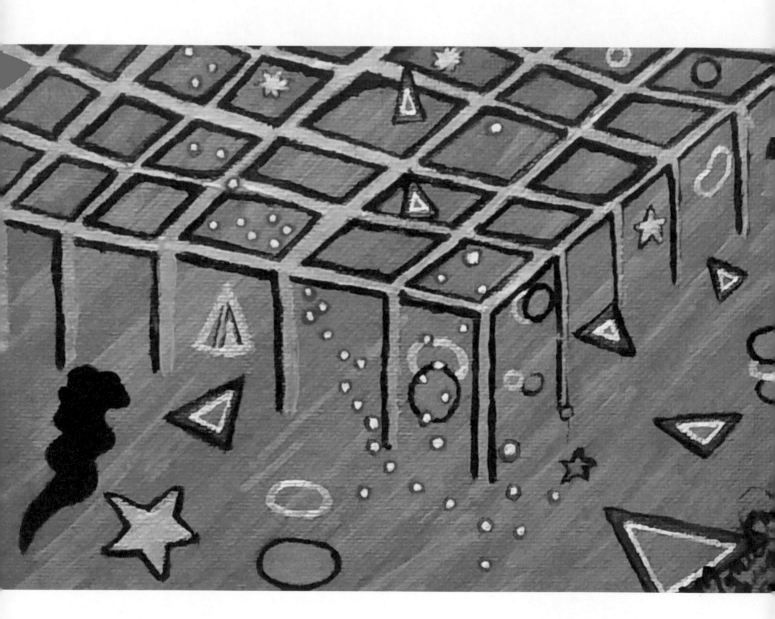

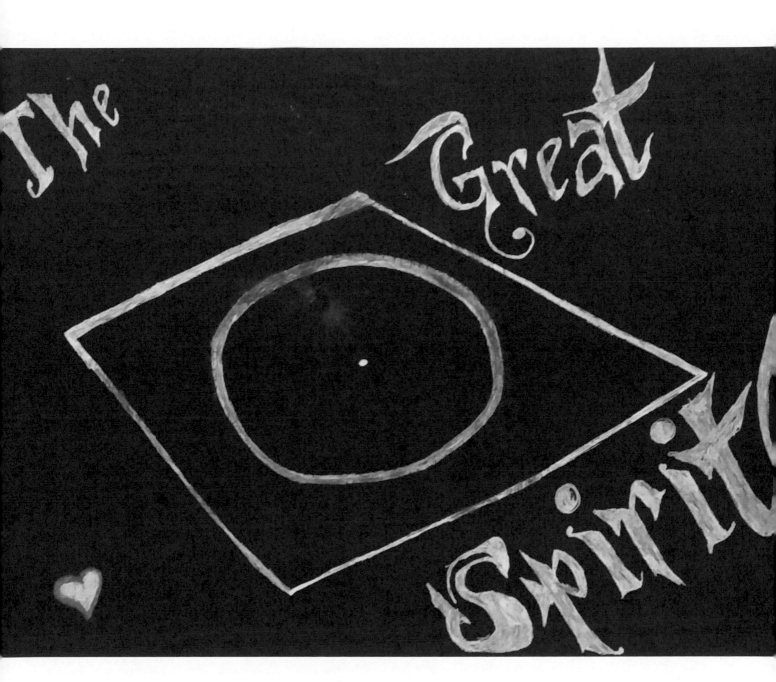

THE GREAT SPIRIT

17

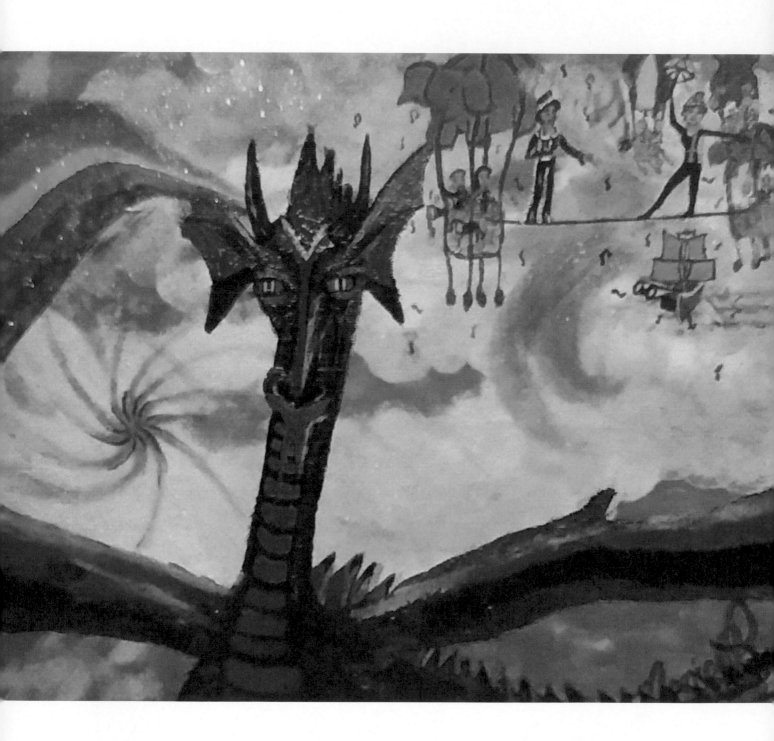

WHAT'S GOING ON?

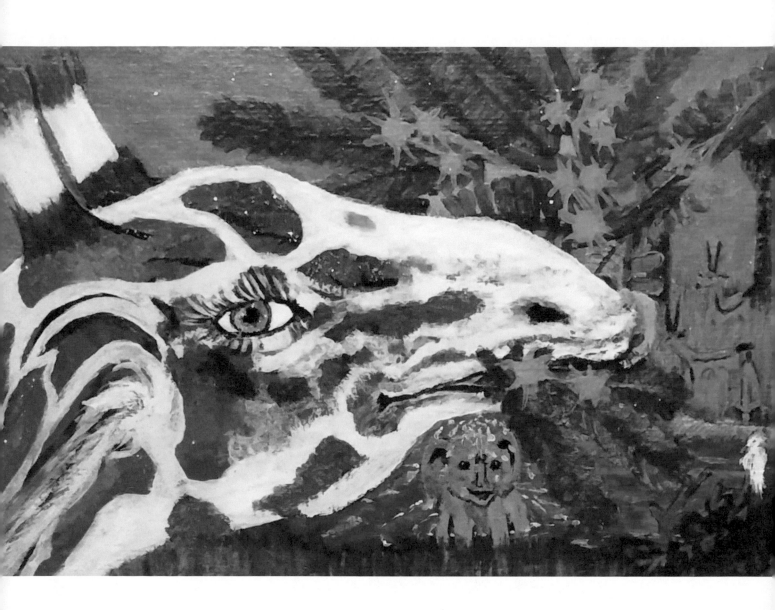

LIFE IN AFRICA

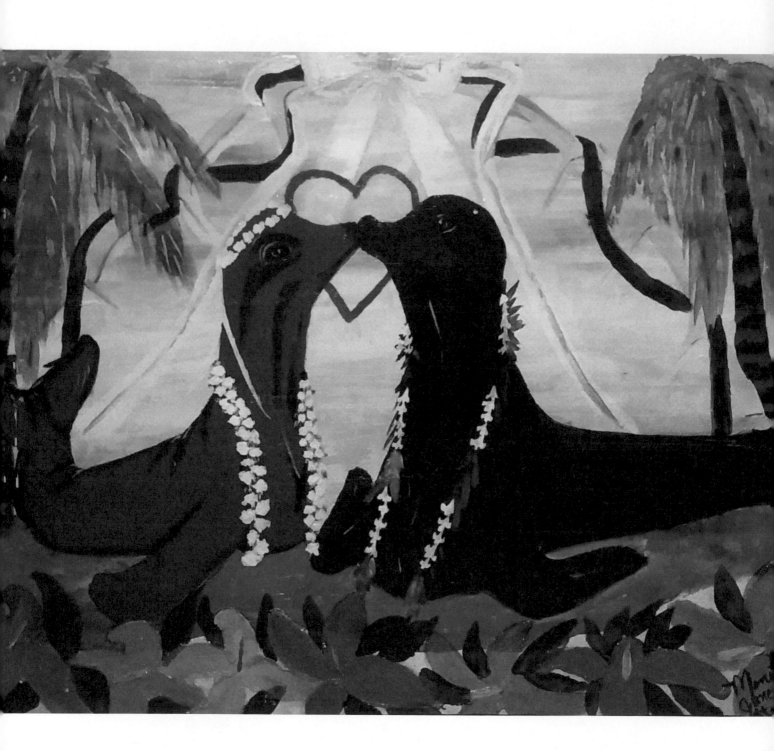

SUMMER SOLSTICE WEDDING

Printed in the United States
by Baker & Taylor Publisher Services